The Pocket Guide to Perspective

A Step-by-Step Approach

The Pocket Guide to Perspective

A Step-by-Step Approach

Maurice Herman

ORO Editions

Publishers of Architecture, Art, and Design

Gordon Goff: Publisher

www.oroeditions.com info@oroeditions.com

Published by ORO Editions

Editor:
Author: Maurice Herman
Book Design: Pablo Mandel, Silvina Synaj / CircularStudio
Project Manager: Jake Anderson

10 9 8 7 6 5 4 3 2 1 FIRST EDITION

ISBN: 978-1-957183-48-0

Color Separations and Printing: ORO Group Inc.
Printed in China

ORO Editions makes a continuous effort to minimize the overall carbon footprint of its publications. As part of this goal, ORO, in association with Global ReLeaf, arranges to plant trees to replace those used in the manufacturing of the paper produced for its books. Global ReLeaf is an international campaign run by American Forests, one of the world's oldest nonprofit conservation organizations. Global ReLeaf is American Forests' education and action program that helps individuals, organizations, agencies, and corporations improve the local and global environment by planting and caring for trees.

Illustration Credits

All illustrations (with the exception of the two public domain illustrations listed below) are original to this guide and were drawn by the author.
The Draughtsman of the Lute, by Albrecht Dürer, n.d., Metropolitan Museum of Art, is in the Public Domain.
"Reflection in Perspective," in *Perspective: The Practice and Theory of Perspective as Applied to Pictures*, by Rex Vicat Cole, is in the Public Domain.

Acknowledgments

To my family, friends and colleagues, whose advice and encouragement was indispensable. Thank you all.

Dedication

To Murray, whose curiosity was infectious.
And to Angie, whose passion for books was passed on to me.

About the Author

Professor Maurice Herman is an award-winning architect, educator, and illustrator. He loves to draw. He's a subject matter expert who's taught perspective, rendering, and sketching for more than twenty years. His illustrations have appeared in numerous books, academic journals, newspapers, and magazines, including the New York Times and Architectural Record.

Contents

Introduction

I learned to love drawing at a very early age. My parents encouraged
me to draw whenever I felt the urge to put crayon to paper. But as a child,
I struggled to make my drawings look like the world around me. The objects
I saw weren't flat like the objects I drew. They had shape and depth, and they
seemed to recede into the distance.

At school one day, I attempted to paint a circus scene that included
a clown on a stage. But I struggled to make the clown appear like he was
standing on a platform. I rendered the stage flat like it was a picket fence
positioned behind the clown. This seemingly simple task was beyond my
abilities. I couldn't conceive of how to draw what I saw in my mind's eye.

The idea of a vanishing point was a foreign concept. It was simply
unknown to me. I was trying to understand how perspective worked.
My parents were no help. They had no knowledge of such things. It was left
to me to figure it out on my own. Eventually I mastered freehand perspective
- or at least the phenomenon of foreshortening when I drew a line of marching
soldiers receding to the horizon.

It wasn't until high school, after learning the mechanics of perspective,
that I fully appreciated its power to render the world realistically - to imagine
how things might be and to make that image come alive. Who knew that
mechanical drafting had such power. It was a very exciting discovery for
a teenager.

Fast forward to design school. I began playing with perspective and
computers in the early 1970s while at CalArts. I tried to perfect a computer

program that translated 3D objects into 2D perspectives. It was a very crude attempt. I couldn't change vantage points or erase hidden lines. I couldn't even spin the object I was studying. But I could capture the translated coordinates, which then had to be manually plotted on graph paper. My feeble efforts serve today only as a pleasant memory and a reminder of just how compelling the study of perspective can be. It's really all about growing one's ability to create imaginary objects. It's all about visualization.

In the computer graphics world of the 1970s and 80s, breakthrough followed breakthrough at a surprisingly quick pace. The key realization was that math was easily applicable to what was, till then, a deeply intuitive process. Texturing, color shading, hidden line removal, and easy scene framing all came relatively quickly. Over time, even 3D modeling became easy. So did photorealistic rendering.

Several years ago, I was asked to teach a class on perspective and rendering. Being mindful that the class I was about to teach only lasted sixteen weeks, I devised a curriculum that, out of necessity, only focused on essential ideas and topics surrounding perspective. The book you see in front of you was born out of the need to help students remember what they learned in class.

Existing textbooks on perspective were mostly too expensive and inappropriate. What I needed were supplemental materials and exercises that mimicked the way perspective was being taught in my classroom. Surprisingly, such materials were not readily available, so necessity soon became the mother of invention.

Building a perspective is a procedurally based process. There are a limited number of visual elements that can be manipulated and a limited number of rules that govern how those elements interact with one another. Change the position of one element and you've altered the appearance of the perspective. Students clearly needed an effective and concise way to understand and remember the process. Given the time constraints, I needed to make the learning process as lean and effective as possible without sacrificing any of perspective's key ideas.

What all that effort has evolved into is this trim little book that encapsulates all the key lessons of linear perspective. If you're looking for a treatise on the topic, you won't find it here. Nor will you find a book about the

significance of perspective in the history of ideas. As worthy of study as those topics are, they're simply outside the scope of this endeavor. What you will find is a pocket guide that teaches you how to draw one, two, and multi-point perspectives as well as shadows and reflections in perspective.

The idea of teaching perspective to college students in the twenty-first century may seem wildly outdated to some given the ubiquity of Computer-Aided Design (CAD) systems and ready access to digital 3D-modeling tools that produce lifelike renderings at the click of a button. But behind all that automation is a process that mimics hand-drawn technique quite closely. It's a process that lends itself to mathematical precision. Indeed, the logic of perspective is inescapable and, as it turns out, it's also very programable. Little wonder then that CAD systems and digital 3D-modeling tools have evolved so quickly and become so popular. It's my fervent hope that understanding traditional perspective technique will allow students to better appreciate the workings of the digital tools they commonly employ and have come to rely on.

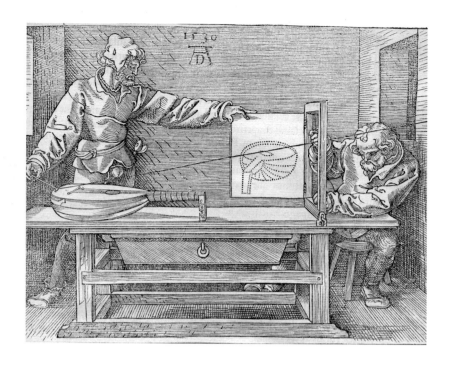

Chapter 1

How to Draw Perspectives: A Step-by-Step Guide

Overview

There are two traditional methods of constructing perspectives in common use today. Both originated in the Renaissance, and both provide reasonably accurate perspectives. The first is what's come to be called the **"Point Cloud"** method. The second is what's called the **"Scaffold"** method.

The Point Cloud method converts locational data from scaled, two-dimensional drawings into a three-dimensional Point Cloud in perspective space (actually a jumble of intersecting lines). *Within the jumble of lines, key intersections are identified and linked together to form object edges and surfaces. The Scaffold method uses cleverly placed diagonal lines to construct a proportionally accurate two- or three-dimensional scaffold into which can be placed any object, building, or in*terior space.

Under the Point Cloud method, Vanishing Points and Horizon Lines are procedurally determined. Under the Scaffold method, the location of Vanishing Points and Horizon Lines are left to the discretion of the artist.

The Point Cloud Technique

The Point Cloud method is most often used by architects, interior designers, city planners, and landscape architects. It requires that the size and shape of the Objects you wish to draw in perspective be already known - even if the design is schematic or preliminary and is likely to change in the future. In practical terms, it means that you have a scaled plan or top view as well as a similarly scaled elevation or side view for all the Objects you intend to draw in perspective before you start.

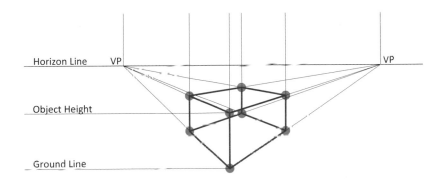

The Scaffold Technique

The Scaffold method is widely used by industrial designers and artists. They find it a bit more intuitive and improvisational than the Point Cloud method. That's because the Scaffold method doesn't need preexisting measured drawings to construct a perspective. You're free to design directly within the scaffold you've established. There's no direct transfer of information between preexisting drawings and the perspective you're creating.

Despite being a perfectly good method of drawing perspectives, the Scaffold technique is deceptively hard to master—a feature that's especially relevant to educators. In contrast, the Point Cloud method, being more procedurally based, lends itself to teaching and easy mastery.

You don't need to be an accomplished artist to master the Point Cloud technique. In fact, you needn't have any special knowledge about art at all. That's the reason we've chosen to feature it in this guide to the exclusion of the Scaffold method.

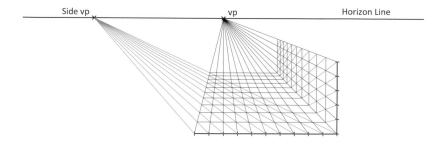

Key Concepts

Observer

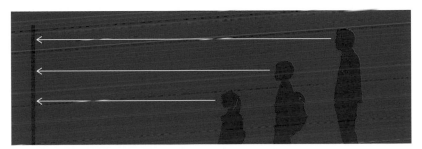

Everyone's horizon is different

The Observer is a stand-in for the audience. He or she appears in elevation and perspective as the Horizon Line (i.e., the Observer's eye level) and in plan as the Station Point. The Observer can be located anywhere in front of the Picture Plane, and in any position relative to the Objects being observed. The Observer's gaze (as seen in plan) is always perpendicular to the Picture Plane.

Objects

Objects are the subjects of the perspective. They are what gets drawn in perspective. They can be any size or shape, and they can be located anywhere in the Observer's field of view. They can be placed as close or as far away from the Observer as desired. They can also be rotated at any angle and can be located above, below, or level with the Observer. They can also be partially obscured from view.

Picture Plane

Picture Plane is the name given to the surface where the perspective is drawn. Traditionally, the Picture Plane is a flat plane that's shown in plan as a straight line. In rare instances, the Picture Plane can also be depicted as a curved line to portray a concave or convex drawing surface.

The Picture Plane can be located anywhere in front of, behind, or astride the Objects being drawn in perspective. In One and Two Point Perspectives, Picture Planes are always perpendicular to the ground plane. This is not the case in perspectives with three or more vanishing points. Nor is it the case with "oblique" map projections where the Picture Plane is obliquely tangent to the globe being mapped.

Note that the terms Picture Plane, Plane of Projection, and Plane of Viewing mean the same thing and are used here interchangeably. Traditionally, the Picture Plane is identified in plan view with the abbreviation "PP."

Horizon Line

The Horizon Line represents the eye level of the Observer. It indicates the farthest distance that can be seen by the Observer in perspective space. It also serves as the anchor for the drawing's one or more Vanishing Points. The Horizon Line is always parallel to the Ground Line and extends from the area where the elevation or side view is drawn to the area where the perspective is being constructed.

The Horizon Line represents the edge of the globe as it appears to an Observer. Because of the relatively small distances involved in each perspective drawing, the phenomenon is said to be "localized," which means it appears as a straight line instead of a curved edge. In other words, the distances involved are well below those that would show the actual curvature of the earth. The abbreviation "HL" is traditionally used to identify the Horizon Line.

Horizon Line ————————————————————————————————————▶

Ground Line

Ground Line
(aka the Common Reference Plane)

The Ground Line (sometimes called the Common Reference Plane) provides a baseline from which all heights can be measured. It's always positioned parallel to the Horizon Line, and it extends from the side view or elevation into perspective space. Ground Lines are traditionally abbreviated "GL."

Projection Lines / Light Rays

In order to detangle all the construction lines that get generated during the drawing process, it's helpful to sort them into four groups. The first group emanates from the Station Point and links both the Object and Picture Plane. The second group extend vertically from the Picture Plane down into perspective space. Each vertical projector starts where lines emanating from the Station Point make contact with the Picture Plane on their way to or from the Object. A third set of projectors are horizontal lines that originate in side view. They carry true height information into perspective space. The fourth set of projectors starts at the Vanishing Points and extends outward. These projectors are used to triangulate the location of all the key points on the Objects being drawn in perspective. For more detailed information about the different types of projection lines, see the "Construction Lines Explained" section in this guide.

Vanishing Point(s)

Vanishing Points are the places where all height lines converge. They are always located on the Horizon Line and only exist in perspective space. The abbreviation "VP" is traditionally used to label each Vanishing Point.

Station Point

The Station Point marks the location of the Observer in plan view. It also establishes the relative location of the Observer to the Object and the Picture Plane. The Station Point may be located anywhere in relation to the Objects being portrayed in the drawing. Note, however, that both the Picture Plane and the Objects must be within the Observer's gaze. As seen in plan, neither can be located behind or below the Station Point.

The center of the Observer's gaze is always perpendicular to the Picture Plane. In other words, a line drawn vertically (in plan) from the Station Point to the Picture Plane must always intersect the Picture Plane at a right angle. An "X" is traditionally used to mark the location of the Station Point in plan. In addition, the abbreviation "SP" is traditionally used to label the Station Point.

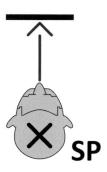

True Height Line

True Height Lines are only found in Perspective Space. True Height Lines are the only places in a perspective drawing where heights drawn in perspective are the same as heights drawn in elevation. They're created when height information is projected from the Side View into Perspective Space from each of the key points on the Objects in elevation.

Cone of Vision

Human eyesight is hemispheric, meaning that our field of view is roughly
180 degrees wide. However, we can only see detail within an arc that's
60 degrees wide. Objects that fall outside this 60-degree Cone of Vision
appear distorted and fuzzy. Illustrators use the Cone of Vision to ensure that
the perspectives they create are balanced and pleasing to the eye.

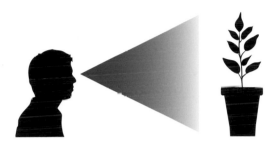

Light Source / Sun

Perspectives can have any number of Light Sources. These Light Sources
can be located anywhere above the Horizon Line in perspective space.
Light Rays emanating from these Light Sources are combined with projec-
tions emanating from the Solar Vanishing Point to triangulate the location,
size, and shape of Shadows cast by Objects in perspective space.

Solar Vanishing Point

The Solar Vanishing Point is located on the Horizon Line, directly below
the Sun (or an artificial Light Source). Projections emanating from the Solar
Vanishing Point and the Sun are used to triangulate the location of key points
of a shadow in perspective space. The abbreviation "SVP" is traditionally
used to label the Solar Vanishing Point.

Shadows

Shadows occur when Objects block Light Rays traveling from their source to a receptive surface.

Entourage

Entourage is the name given to collections of images (either photographic or hand drawn) that are inserted into a perspective to enliven its appearance. They are a fast and cost-effective way of adding detail into a rendered scene. Think of Entourage as ornaments on a Christmas tree. They don't add structure to a perspective; they just add warmth and ambiance.

Linear Perspective

The term "Linear Perspective" is often used interchangeably with what most people call a "Perspective." Its distinguishing characteristic is that all projectors or Light Rays emerging from or converging into its one or more Vanishing Points are all straight lines. In contrast, the same projectors or Light Rays in a curvilinear perspective are arched or curved.

Descriptive Geometry

Descriptive Geometry is a system of rules that define how 3D Objects or physical phenomena are portrayed in two dimensions. Note that within this guide, the terms Descriptive Geometry and Projective Geometry are taken to mean the same thing and are used interchangeably.

Convergent Projections

Convergent Projections are one of two major categories within Descriptive Geometry (the other being Paraline Projection). Unlike Paraline systems, projectors in convergent systems are NOT parallel to one another, which means that will inevitably converge with one another somewhere in 3D space. In other words, every drawn Object is connected to one or more points of origin via projectors. Depending on the system employed, projectors are either straight lines (as in the case of Linear Perspective and most mapping systems) or curved (as used in curvilinear perspective and several other mapping schemes). The defining characteristic of Convergent Projection is that any object drawn within this system appears to recede into one or more points of origin.

Single Point Perspective

Single Point Perspectives are a type of convergent projection. 3D Objects drawn in Single Point Perspectives appear to converge into a single point on the drawing's horizon. The existence of only one Vanishing Point is the defining characteristic of this type of projection. In Single Point Perspective, at least one object face is parallel to the Picture Plane.

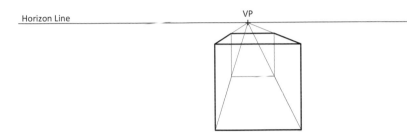

Two Point Perspective

Two Point Perspectives are a type of convergent projection. 3D Objects drawn in Two Point Perspectives appear to converge into two different points on the drawing's horizon. The existence of two vanishing points is the defining characteristic of this projection method. In Two Point Perspective, no object face is parallel to the Picture Plane.

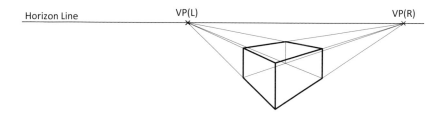

Three Point Perspective

Three Point Perspectives are a type of convergent projection. 3D Objects drawn in Three Point Perspectives appear to converge into three different points (two on the drawing's horizon and one above or below the Horizon Line). The existence of three Vanishing Points is the defining characteristic of this projection method. In Three Point Perspective (as is the case with Two Point Perspectives), no object face is parallel to the Picture Plane.

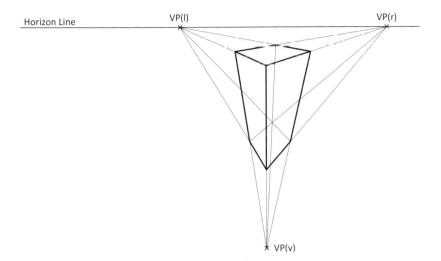

Horizon Line VP(l) VP(r)

VP(v)

Multi-Point Perspective

Multi-Point Perspective is the term used to describe a drawing that contains several different perspectives. These perspectives are arranged so they overlap or abut one another. All share a common Horizon Line, Ground Line, Picture Plane, Station Point, plan, elevation, and scale. They don't, however, share the same Vanishing Points. To most viewers, this type of composite image is extremely lifelike and pleasing to the eye.

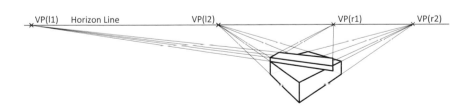

VP(l1) Horizon Line VP(l2) VP(r1) VP(r2)

Angle of Incidence

The term Angle of Incidence describes the included angle that's generated by the path a Light Ray takes as it travels toward a mirror and an imaginary line that extends from that Light Ray's point of contact with the mirror upwards at a 90-degree angle.

Angle of Reflection

The angle that a ray of light travels as it bounces off a mirror is called the Angle of Reflection. It's defined as the included angle that occurs between the Light Ray's path of travel and an imaginary line that extends upwards at a 90-degree angle from the Light Ray's point of contact with the mirror. In mathematical terms, the perpendicular line is called the "Normal." The Normal acts as the reflection's axis of symmetry, thus ensuring that the Angle of Reflection is always equal to the Angle of Incidence.

Axis of Symmetry

An Axis of Symmetry acts as a mirror. It splits an image into two identical halves. Each side of a symmetrical image looks exactly like the other's mirror image.

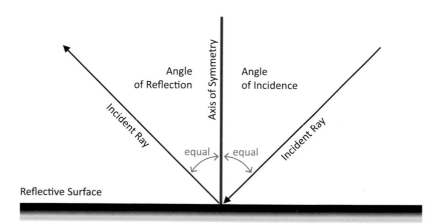

Computer-Aided Design
or Computer-Aided Drafting (CAD) Systems

A CAD system is a collection of specialized computer equipment and software that's capable of portraying real or imagined Objects in two or three dimensions. From their inception, CAD systems were designed to automate the process of hand drafting. They've proven so successful at that task that today, CAD systems have effectively made hand drafting obsolete.

Manual Drafting

Manual drafting is the practice of creating two- and three-dimensional drawings by hand using traditional drafting tools, equipment, instruments, and techniques.

Step-by-Step Sequence

Phase 1: Preparations

1. Familiarize yourself with these instructions thoroughly before you begin.
2. For best results, visualize each step before actually attempting it.
3. Gather all required supplies. For a complete list of required supplies and equipment, see the "Media Selection and Supplies" section of this guide.
4. Adjust your chair, work surface, and light for ergonomic comfort.
5. Draw a series of thumbnail sketches to help you envision what your finished product will look like. As an alternative, if the scene already exists in real life, take photographs from several vantage points to help you determine the most appealing view.

Phase 2: Planning

Intro

1. These instructions explain how to lay out a perspective from scratch. They do not explain how to use preprinted, commercially available perspective grids.
2. The perspective construction process described in these instructions requires you to merge plan and elevation data together to create a perspective. If all three views (i.e., plan, elevation, and perspective) are small enough, you'll be able to fit your work onto a single sheet of paper. But that's not always possible or advisable. Sometimes the size of paper required to contain all three views on a single sheet of paper exceeds the size of your drafting table or work surface. If that's the case, you'll need to separate each view onto its own sheet of paper, scale down your drawings or change the relative angle between the plan and the Picture Plane.
3. Traditionally, side views or elevations are located to the left of perspective space and plan views are located directly above perspective space. But this arrangement is neither necessary nor required.

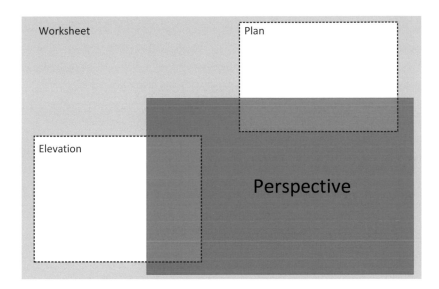

Worksheet

Plan

Elevation

Perspective

Alignment Marks

1. Drafting tables and work surfaces are often disassembled and moved, which means that sheets containing partially completed perspectives may need to be stored for travel and reassembled when work resumes; so, if more than one sheet of paper is used to create a perspective, each must contain a set of alignment marks so the base sheet and its overlays can be perfectly realigned and reassembled.

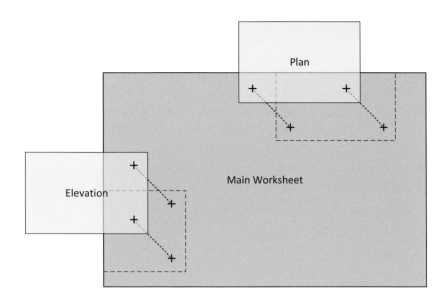

Scale

1. As you decide which scale to use, consider the following:
2. The scale you select will determine the overall size of each view you draft.
3. The size of your workspace (aka your drafting table or work surface) will also limit your choice of scale. Too big a scale will exceed the size of your work surface.
4. The desired size of your finished perspective will likewise limit your choice of scale.
5. Be consistent. Use the same scale when drafting the plan and the elevation.

Phase 3: Set Up

General

1. Secure the sheet of paper you'll be using to a table or drafting surface.
2. Carefully measure or verify the dimensions of each object you want to draw in perspective.
3. Select an appropriate scale for your drafting.

Setting Up the Elevation

1. Draw an elevation showing all the Objects you intend to draw in perspective. Be sure that all object heights are accurately drawn and that they're drawn in the same scale as your plan.
2. If you're creating a perspective on a single sheet of paper, locate the elevation near the lower left corner of your paper. If you're drawing the elevation on a separate sheet of paper, center your work and be sure to include alignment marks on both your elevation sheet and your main worksheet.

Ground Line

1. Draw a Ground Line in elevation and extend it into perspective space.

Drafted Heights

1. Draw the side view or front elevation of every object that will be included in your perspective. As you draw, pay special attention to the heights of Objects. Usually, Objects are anchored to the ground, but that's not always the case (think airplanes and submarines).
2. Number or label every key point on each object shown in elevation. Be sure that all labels correspond to the same points in plan.
3. Draw construction lines from all the key points on the Objects shown in elevation into perspective space.

Horizon Line

1. Decide how far above or below the Ground Line to place the Horizon Line. Draw the Horizon Line in elevation and then extend it into perspective space. Make sure that you use the same scale to indicate heights as was used to draw the plan.

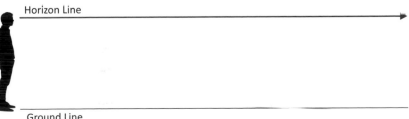

Horizon Line

Ground Line

Setting Up the Top View or Plan

Drafting

1. If you're creating a perspective on a single sheet of paper, locate the plan near the upper right corner of your paper. If you're drawing the plan on a separate sheet of paper, center your work.
2. Draw a plan or top view showing the Objects you intend to draw in perspective. Be sure that all Objects are accurately oriented to one another and that they're drawn at the same scale as your elevations.
3. Make sure that both the distance and the relative angle between the Objects and the Observer are drawn accurately.
4. Number or label every key point on each object shown in plan. Be sure that all labels correspond to the same points in the other views.
5. If necessary, label each of the key points to help keep track of construction line intersections.
6. Objects may be oriented to one another in any position desired and entire plans can be rotated to any angle. It's imperative that you use the same scale to prepare both the plan and the elevation.

Station Point

1. Locate the Station Point in plan. Remember that the distance between the Object and the Observer should be drawn to scale and that any angular offset between Object and Observer should also be shown accurately.
2. The farther away the Station Point is from the Objects, the smaller the Objects will appear in perspective. Conversely, the closer the Station Point is to the Objects, the larger they will appear in perspective.
3. For best results, locate the Station Point at a point that just manages to capture all the Objects within a 60-degree Cone of Vision. Remember, Objects that extend beyond the Cone of Vision will appear distorted.

Cone of Vision

1. Draw a 60-degree Cone of Vision anchored to the Station Point. Match the centerline of the Cone to the centerline of the Observer's gaze (i.e., the perpendicular line drawn from the Station Point to the Picture Plane).

2. Make sure that in plan, the area you are most interested in portraying falls completely within your Observer's Cone of Vision. Objects that fall outside the Observer's Cone of Vision will appear distorted. Feel free to adjust the location of either the Station Point or the plan to ensure a distortion-free perspective.

Picture Plane

1. Draw the Picture Plane. The Picture Plane can be positioned anywhere in relation to the Objects shown in plan (i.e., it can be placed in front of, in back of, or astride of the Objects in your scene).
2. In most cases, it's useful to position the Picture Plane so it touches one or more key points on Objects in plan. This will allow you to bring true height information directly into your perspective from the elevation without the need for additional construction lines or projections.
3. Objects located behind the Picture Plane in plan will appear small in perspective. Objects that fall in front of the Picture Plane will appear enlarged, and Objects that intersect the Picture Plane will appear normal size and undistorted.

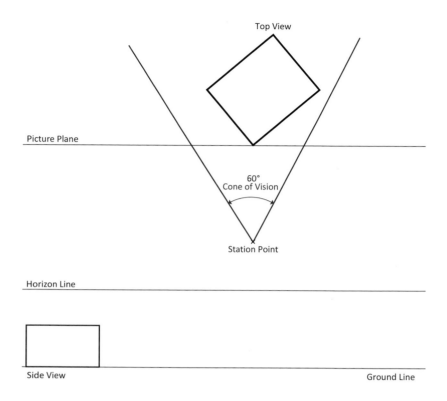

Setting Up Perspective Space

Sheet Layout

1. Locate an area in the lower righthand quadrant of your work area
 where you can draw your perspective. Make sure the area is large enough
 to accommodate widely separated vanishing points.
 Reminder: your perspective can be placed on its own separate sheet
 of paper or it can be placed on the same sheet of paper as the plan
 and the elevation.
2. Check to see that both the Ground Line and the Horizon Line
 have been extended into perspective space. If not, extend both lines.

Vanishing Point(s).

1. Locate the Vanishing Point(s) on the Horizon Line. In One Point Perspectives, the location of the Vanishing Point is determined by drawing a vertical line from the Station Point to the Picture Plane.

 In Two Point Perspectives, the location of the left and right Vanishing Points is determined by drawing a construction line from the Station Point to the Picture Plane from the left and from the right that is parallel to the front faces of the object that's closest to the Picture Plane.

 In both One and Two Point Perspectives, a construction line is then drawn vertically from the point of intersection at the Picture Plane (down) to the Horizon Line. Vanishing Points are established at the point of intersection with the Horizon Line.

2. In Two Point Perspectives, Vanishing Point spacing is subject to a number of variables (i.e., the overall size of the Objects being drawn, the scale at which they are drawn, the distance between the Station Point and the Picture Plane, as well as the relative angle of the plan to the Picture Plane); so the sheet of paper you use to create your perspective must be big enough to accommodate widely spaced Vanishing Points.

3. In Two Point Perspectives, the relative angle between the Picture Plane and Objects in plan determines the distance between Vanishing Points. If one of those angles is too acute, the distance between Vanishing Points may exceed the width of your work surface, in which case the angle must be adjusted; or alternatively, a way of accurately extending the horizon line beyond the confines of your drafting table must be found (e.g., railroad curves).

4. In One Point Perspectives, Objects shown in plan have at least one face that's parallel to the Picture Place. In Two Point Perspectives, none of the object surfaces shown in plan are parallel to the Picture Plane.

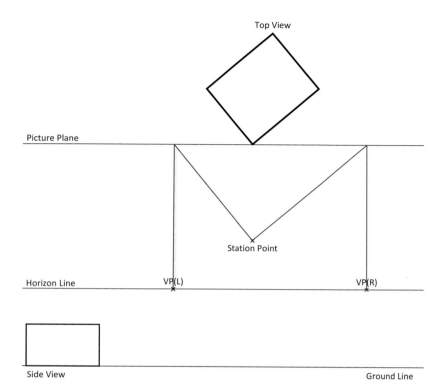

Top View

Picture Plane

Station Point

Horizon Line VP(L) VP(R)

Side View Ground Line

Phase 4: Creating the Perspective

Projectors from Station
Point to Objects and Picture Plane

1. Draw construction lines from the Station Point to all the key points on every object shown in Plan. If the Picture Plane is located behind the Objects, extend these lines until they intersect the Picture Plane.
2. It may be advisable to label each of the key points to help keep track of construction lines.

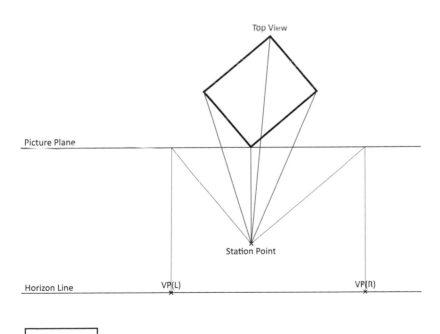

Verticals

1. Note where the lines linking the Station Point to the Object intersect the Picture Plane. Then, bring down vertical lines from each of these intersections into perspective space until they intersect the horizontal "height" lines that were previously projected across the paper from the elevation or side view.

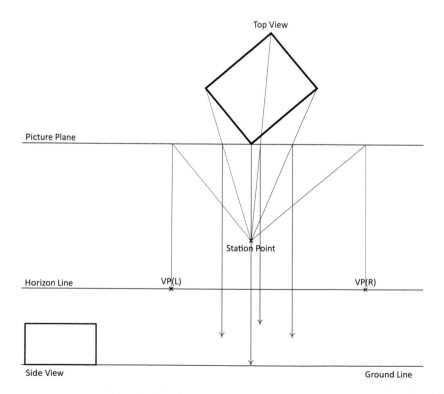

Creating True Height Lines in Perspective

1. Identify any points on an Object shown in plan that touches the Picture Plane. These points will serve as true height lines in perspective.
2. If none of the Objects shown in plan touch the Picture Plane, an artificial True Height Line must be constructed. The best way of doing that would be to extend a line from any of the object's corners (preferably the one that's closest to the Picture Plane), until it intersects the Picture Plane. Make sure that the extension line is parallel to the object's surface.
3. Identify the horizontal projectors coming from the elevation that correspond to the top and bottom points on the edge of the object that's touching the Picture Plane and note where they intersect the vertical projector that originates at the point where the Object touches the Picture Plane. The line between these two intersections is the True Height Line. Darken this line.
4. Extend a pair of lines from a Vanishing Point to the top and bottom of the True Height Line. Then, extended those lines further into perspective space.

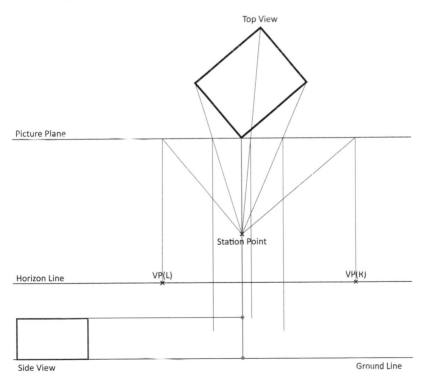

Top View

Picture Plane

Station Point

Horizon Line VP(L) VP(R)

Side View Ground Line

5. Identify the intersections that define the edges of the surfaces that lie directly to the left and right of the first True Height Line.

Connecting the Dots

1. Draw construction lines from the top and bottom of the True Height Line to the vanishing point(s). Note where the lines going to the vanishing point(s) intersect other projection lines coming from above. These are the key points that define the perimeter of the surfaces that abut the True Height Line.
2. Going from point to point, darken the outline of each enclosed surface.
3. Starting from these front surfaces and working back toward the Horizon Line, locate all the other key points on Objects shown in plan and draw those corresponding edges in perspective space.
4. Repeat this process until all the Objects shown in plan are also shown in perspective.

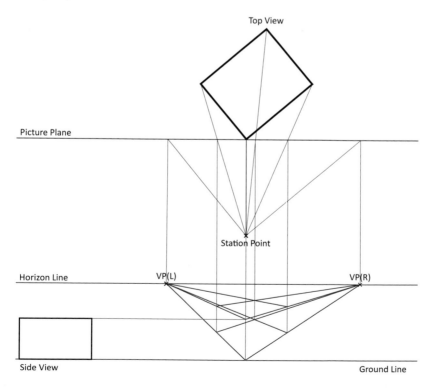

Good Housekeeping

1. Construction lines have a tendency to proliferate as a perspective is being built so common sense and best practice dictates that that you periodically erase obsolete or unnecessary lines from your work. Obsolete lines serve to obscure and confuse more than help the process.

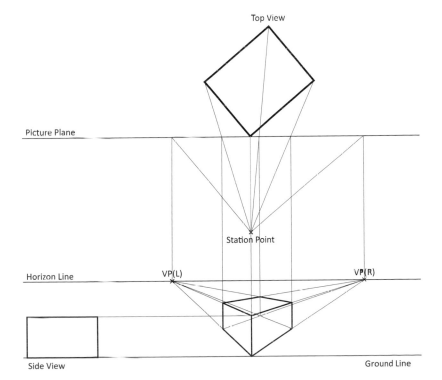

Top View

Picture Plane

Station Point

Horizon Line VP(L) VP(R)

Side View Ground Line

Phase 5: Rendering and Finishing

1. Add Entourage to the completed perspective.
2. Clean up and make copies of the completed perspective.
3. Erase any unwanted construction lines.
4. Make copies of the completed perspective.
5. Complete a set of practice renderings to test color palettes and media application.
6. Gather all you've learned and apply that knowledge toward the completion of a final rendering.

Picture Plane

×
Station Point

Horizon Line VP(L)
 ×

Side View

Drawing Tips

Housekeeping

Over time, as you add more detail to your perspective, your drawing will become increasingly cluttered with construction lines. As a practical matter, its best if you erase construction lines as soon as they're no longer needed.

Sequencing (Should I draw things Front to Back or Back to Front?)

Sometimes it's useful to start your perspective by drawing the Objects and surfaces that are closest to the Observer and then to draw Objects that are progressively more distant. Working this way allows you to identify overlapping Objects and surfaces which can potentially save you some time since you can avoid drawing features that are hidden from view. At other times however, it's useful to draw Objects and surfaces from back to front. That way, you're guaranteed not to miss anything. Everything you see in plan will be represented in your perspective.

Drawing Strategies

Illustrators use two different (often competing) strategies to draw perspectives. In the first (let's call it the "Kitchen Sink" method), all required construction lines for the entire perspective are drawn before object corners and surface edges are identified and visually highlighted. In the second (let's call it the "String of Pearls" strategy), illustrators only draw the construction lines for one object at a time. The only construction lines on the page at any given moment are associated with the one object or surface that's currently under construction. New construction lines are added only after previously drawn surfaces have been defined and their associated construction lines erased. Drawing single Objects or surfaces, tends to minimize visual clutter on the page.

Keeping Track of Corners

Tag the corners of every object shown in plan and elevation with a unique identifier (i.e. a number or letter). This will help you sort through the jumble of construction lines to pinpoint the exact location in perspective space of each corner and surface edge.

Color Code your Construction Lines

Some illustrators find it useful to color code their construction lines. You can do this two different ways: Lines can be color coded by function (i.e. each type of line is drawn in a different color). This is most often used in the **"Kitchen Sink"** method.

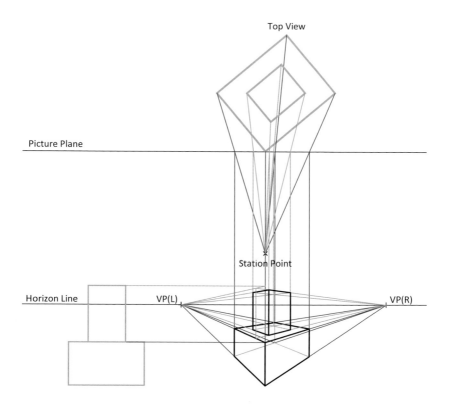

"Kitchen Sink" color coding

Alternatively, construction lines can be color coded by object (i.e., all the construction lines associated with a specific object or surface are drawn in the same color). This approach is most often used in the **"String of Pearls"** construction method. Both strategies work equally well provided of course that you don't mix them in the same drawing.

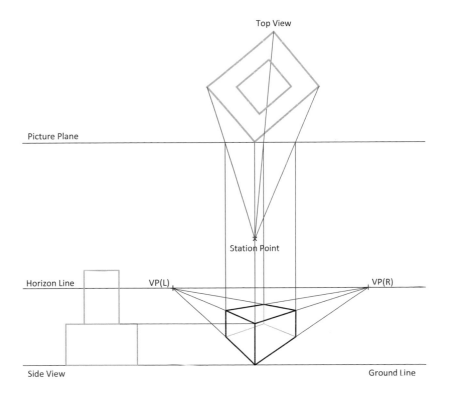

"String of Pearls" color coding (bottom object)

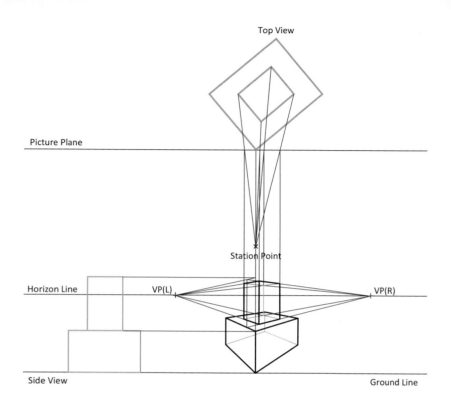

Top View

Picture Plane

Station Point

Horizon Line VP(L) VP(R)

Side View Ground Line

"String of Pearls" color coding (top object)

Construction Lines Explained: What Should I Draw First?

Every perspective contains five different types of construction lines. Each type of line is used for a specific purpose and is best applied at a specific point in the drawing process. The order in which you draw your construction lines is important, but as you'll see, you have some flexibility in determining the sequence you use. Here's a brief description of each type of construction line and advice as to when to insert them into your drawing:

Category #1

All the lines in Category #1 originate at the SP and extend to the corners of each object shown in plan. These lines must be in place before any vertical lines (i.e., Category #4 lines) can be drawn.

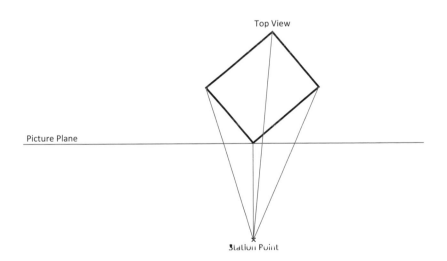

Top View

Picture Plane

Station Point

Category #2

All the lines in this category are anchored to key points on Objects shown in elevation or side view and projected horizontally into perspective space. These lines must be in place before convergent lines (i.e., Category #5 lines) are added to your perspective.

Top View

Picture Plane

×
Station Point

Horizon Line

Side View

Ground Line

Category #3:

Lines in this category are used exclusively to determine the location of a drawing's Vanishing Points. Locating the vanishing point in a One Point Perspective is relatively easy and uncomplicated since you only have to draw one vertical construction line between the SP and the Horizon Line. Two Point Perspective on the other hand are a bit more complicated.

They require two lines on each side of the SP (i.e., one pair of lines to locate the VP on the left and one pair of lines for the Vanishing Point on the right). All Category #3 lines must be in place before any convergent lines (i.e., Category #5 lines) can be added to your perspective.

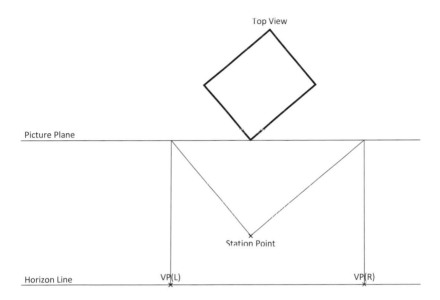

Locating the Vanishing Points in a Two Point Perspective.

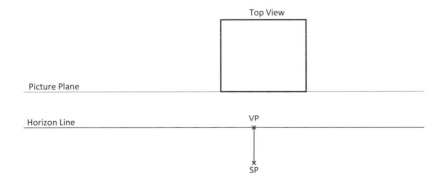

Locating the Vanishing Point in a One Point Perspective.

Category #4

In this category, vertical lines descend from the PP into perspective space. The vertical lines start where the diagonal lines stretching between the SP and the Object intersect the Picture Plane. Vertical lines can only be drawn after the diagonal lines from category #2 have been added to your drawing.

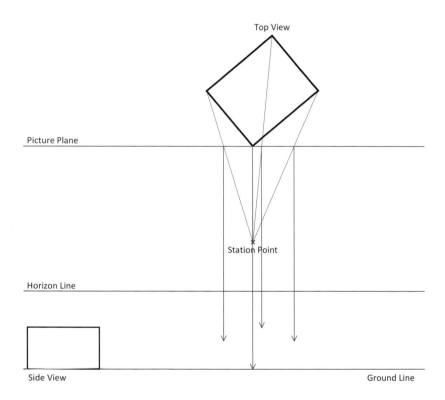

Category #5

This group of lines converge on Vanishing Points. They originate at the inter-section of horizontal and vertical construction lines located in perspective space. Convergent lines can only be drawn after the Vanishing Points have been established and one or more pairs of horizontal and vertical lines have been joined together.

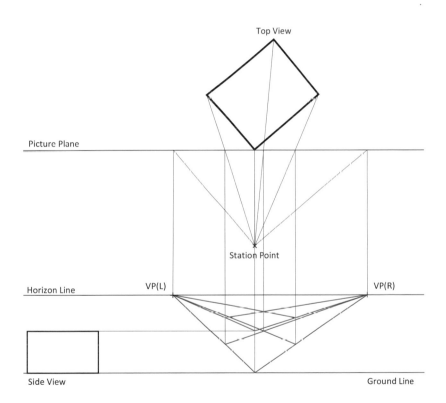

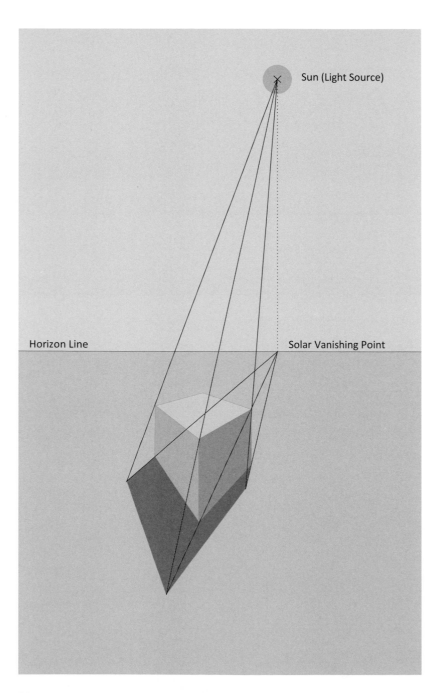

Sun (Light Source)

Horizon Line

Solar Vanishing Point

Chapter 2

How to Draw Shadows in Perspective; a Step-by-Step Guide

Overview

This tutorial will teach you how to draw Shadows in perspective. You'll note that the example we've chosen to use for this tutorial is a Two Point Perspective; but the process we're using also works equally well on One Point Perspectives. Shadows can be fairly difficult to construct in perspective. This is especially true if the Objects casting the Shadows have complex shapes or are floating above the ground and are oriented irregularly to the ground or the Observer. To explain how the process works, in as simple a manner as possible, we've elected to place a large box flat on the ground.

Sequence:

1. Place the Sun (aka the "Light Source") anywhere in your perspective above the horizon line and mark that spot with an "X."
2. Project a line vertically down from the center of the Sun to the Horizon Line. Designate the resulting intersection as the Solar Vanishing Point (SVP).
3. Draw construction lines from the Solar Vanishing Point through each corner on the bottom of the box. Be sure to extend these lines well beyond the corners.
4. Draw construction lines from the center of the Sun to the top corners of the box. Be sure to extend every construction line well beyond each corner until they intersect the lines coming from the SVP. Designate each resulting intersection as a corner of the box's shadow.
5. Note where all of the intersections occur and draw lines connecting all of those intersections. The resulting enclosed area represents the shadow of the box.
6. Fill in, shade, or crosshatch the enclosed area.

How to Draw Reflections in Perspective; a Step-by-Step Guide

Overview

This tutorial will teach you how to draw reflections in perspective. Constructing a reflection in perspective can be challenging, especially for novices. Mirrors can obviously be positioned anywhere in perspective space and oriented at any angle relative to the viewer which makes for a potentially confusing projection process. So, to simplify matters, we've chosen to place a reflective surface directly below an existing perspective. By placing a mirrored surface directly below the Objects already drawn in perspective, we've made the resulting reflection intuitively easy to understand and very simple to draw.

Sequence

Phase 1: Preparations

1. Thoroughly familiarize yourself with these instructions before you begin. If there's anything you don't understand after reading these instructions, please feel free to ask for clarification at any time.
2. Gather up your supplies. You'll be using many of the items listed on the Media Selection and Supplies page of this guide, so read over the list and take stock of your existing supplies. If you find anything missing in your inventory, take whatever steps are necessary to obtain the missing items as quickly as possible.

Phase 2: Planning

1. You'll be adding a reflection to an existing perspective; so, search your records to find a recently completed One or Two Point Perspective. By using an existing perspective, we can eliminate a great deal of preparatory work. For instance, you've already drawn the Horizon Line, located the Station Point and Picture Plane, located the Vanishing Points and established the relative heights of all the Objects shown in perspective. The only thing left to do is add the upside-down elevation and incorporate its height information into the perspective; so, let's proceed.

2. Carefully examine the perspective you've chosen. As you look it over, make sure that the plan, elevation, Horizon Line, Picture Plane, Ground Line, Vanishing Points, and Station Point are all clearly visible. If not, find another perspective to work with.

3. Check to see that the sheet of paper containing the existing elevation and perspective is large enough to accommodate a new elevation that will be positioned directly below the existing one and a reflection that will be positioned directly under the existing perspective.

4. If your paper isn't large enough, or doesn't have enough unused or blank space, add an overlay to accommodate the new material.

5. If you're adding an overlay, draw a set of alignment marks so the base sheet and the overlay can be accurately reassembled.

Phase 3: Set Up

General

1. As you begin each work session, adjust your chair, work surface, and light for ergonomic comfort.

2. Tape your perspective to your drafting table or work surface. If your perspective has overlays, make sure they're properly aligned as you tape them down.

3. Your task is to draw a mirror image directly below an existing perspective. To do that, you'll be reusing the existing plan, elevation, Ground Line, Horizon Line, Station Point, Picture Plane, Vanishing Points, on the perspective you've chosen so *don't change or modify them in any way.*

Setting Up the Elevation

1. Draw an upside-down version of the existing elevation. Anchor the bottom of the upside-down elevation on the Ground Line directly below the existing right-side up elevation. Remember to use the same scale you used to create the original, right-side up elevation.

2. Number or label every key point on each Object shown in your upside-down elevation. Then, add the same labels to your plan.
 These labels are the only changes you'll be making to the plan.

3. Check to ensure that both sets of labels have been accurately placed and well-coordinated. Make corrections as needed.

4. You're going to use the height information from the newly drawn upside-down elevation to construct a True Height Line for the reflection; so, draw horizontal construction lines from all the key points on the upside-down elevation into perspective space.

Phase 4: Creating the Perspective

Review

Let's revisit the steps you took to create your original perspective.
First, you determined the relationship between the Observer and Object in plan. Then you positioned the Picture Plane. Next, you determined the Observer's eye height, which established the location of the Horizon Line on your drawing. Then, you were able to determine where the Vanishing Point(s) landed on the Horizon Line. Then, after you brought over the object height information from the elevation, you were able to establish a True Height Line in perspective. Once the True Height Line was established, you were able to determine the location and shape of every surface in perspective by systematically projecting corner points back to a Vanishing Point.

Here's a few things to keep in mind as you begin constructing your reflection:

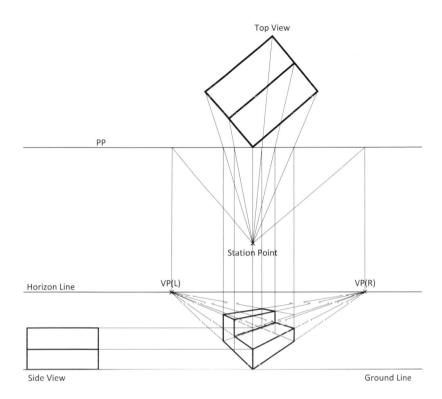

Top View

PP

Station Point

Horizon Line VP(L) VP(R)

Side View Ground Line

1. Many but not all surfaces that you see in your existing perspective will have a reflection.
2. Reflections are mirror images of real-life objects. They always appear to be the same size as the originals. In other words, the upside-down reflections you'll be drawing will be the same size as the previously drawn "right-side up" perspectives.
3. Perspective reflections always share the same Vanishing Point(s) and Station Point as right-side up twins since the relative position of the Observer to the Picture Plane hasn't changed, nor has the distance from the Ground Line to the Horizon Line (i.e., the Observer's eye level hasn't moved).

Construction

1. Find the True Height Line in the existing perspective and extend it downward, well below the bottom of the existing perspective.

2. Find the corresponding horizontal line coming from the upside-down elevation and note where the horizontal and vertical lines meet. The resulting line will serve as the True Height Line for the reflection.

3. Project lines back to Vanishing Point(s) from the top and bottom of the reflection's True Height Line.

4. Extend every vertical line in your original perspective downwards.

5. Note where the lines going to the Vanishing Point(s) intersect the vertical lines coming from above. These intersections represent the corners of a flat plane that's front edge is the reflection's True Height Line. Darken in the outline of the enclosed plane.

6. Repeat this process until every surface shown in the original perspective is also shown as a reflection. Work from the middle of the scene outwards toward both left and right edges, connecting each new surface to one that was previously drawn.

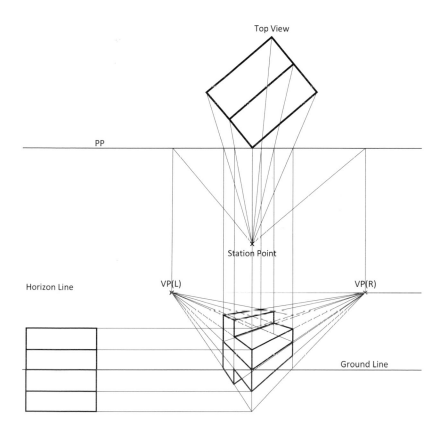

Good Housekeeping

1. At the end of each work session, gather up all your supplies
 and equipment and clean up your workspace. Find a safe place to store
 your work-in-progress as well as your supplies and equipment.

Phase 5: Finishing Touches

1. Erase any unwanted construction lines.
2. Add Entourage to the completed perspective if desired.
3. Scan your completed work. Then, edit the resulting digital image as needed.
4. Archive your work in a safe place but keep it handy. You'll probably want to use it in your portfolio.
5. Post your work on social media so others can see what you've accomplished.

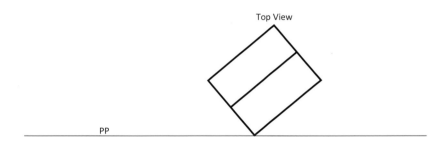

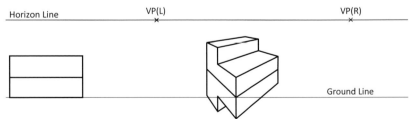

Chapter 4

Perspective Exercises and Solutions

Exercises **Solutions**

Overview

Being able to construct a perspective is a procedurally based skill.
The process uses a set of rules to control how visual elements relate to one another on a page. Under the rules, each visual element can only be manipulated in a limited number of ways. Change the location of any visual element, and you'll alter the appearance of the perspective. The nine exercises that accompany this book address each of those options in a way that will allow you to methodically build your understanding of the subject. Think of them as a set of scientific experiments that are designed to help you learn the basic concepts of perspective construction.

Downloading the Exercises

You can download the entire set of nine exercises and their solutions from the ORO Editions website for free. Simply point the camera on your smartphone or tablet to the **QR codes** shown above and follow the links.
The current versions of both iOS, iPad OS and Android can read QR codes automatically. If you're not sure how to do this, consult your device's help menu or search for any of the many instructional videos on the subject you can find online.
Older phones and tablets (i.e., devices running Android 7 or older and iOS 10 or older) may not be able to read this QR code without the help of a QR Code Reader app. If that's the case, visit your favorite online app store and download a suitable app. Once the reader has been installed, you can proceed with the download scan.

When downloading is complete, feel free to print out as many copies as you wish.

Media Selection and Supplies

The exercises you've just downloaded will test your ability to draw One, Two, and Multi-Point Perspectives, as well as Shadows and Reflections in perspective. Readers are obviously free to complete these exercises by hand using traditional media or with a computer using Computer-Aided Design software. This guide can be used with either approach.

If you've chosen to use traditional hand-drafting techniques to complete these exercises, you'll need at least one mechanical pencil or lead holder with an assortment of different leads, an eraser, drafting tape or dots, a large triangle or straightedge, a parallel straightedge or T square and a comfortable workspace with plenty of light. You'll also need some tracing paper.

If you've chosen to use Computer-Aided Design software to complete these exercises, make sure your computer is powerful enough to run your chosen software. Check the developer's website to see if your computer equipment meets or exceeds the developer's minimum hardware and software requirements. If it doesn't, you'll need to upgrade your setup before you begin.

Also, before attempting the exercises, check to see that both your computer's operating system and the CAD system you've chosen is up-to-date and running properly.

Perspective Exercise Instructions

Overview

1. Thoroughly familiarize yourself with these instructions before you begin.

2. The nine exercises you've downloaded are designed to test your understanding of perspective construction. Exercises #1 through #4 will test your ability to draw One Point Perspectives. Exercise #5 will test your ability to draw Two Point Perspectives. Exercise #6 will test your ability to draw Multi-Point Perspectives. Exercise #7 will test your ability to draw reflections in perspective. Exercises #8 and #9 will test your ability to draw Shadows in perspective.

3. Readers are free to complete these exercises using traditional hand-drafting techniques or with a computer using Computer-Aided Design software. These instructions can be used with either approach.

4. Study each exercise worksheet carefully and note the relative position of all the elements on the page (e.g., the location of the Observer, Picture Plane, Ground Line, as well as the size and position of the Object shown in plan and elevation).

5. You'll note that hand drafting and CAD drafting each have their own set of instructions below. Follow the instructions that fits your work method.

Phase 1: Preparation

(Hand-Drafting Instructions)

1. If you choose to complete these exercises using traditional hand-drafting techniques, you'll need to outfit yourself with a drafting table, drafting pencils, tape, erasers, triangles, and some form of straightedge like a T square or parallel bar.
2. Find a comfortable location where you can work on these exercises. Make sure your work area is well ventilated, has plenty of light, and that there's enough space around to lay out your supplies and equipment.
3. Arrange your supplies and equipment so they're readily accessible. Then, adjust your chair, work surface, and light for ergonomic comfort.
4. Clean your drafting equipment and work surface before you begin drawing.

(CAD Instructions)

1. If you've decided to complete these exercises using a Computer-Aided Design system, make sure your CAD software and the operating system it runs on is up-to-date and working properly.
2. You'll also need a reasonably fast and reliable internet connection and an up-to-date web browser. In addition, you'll also need access to a printer.
3. Finally, you'll also need a USB memory stick, external hard drive, or access to Cloud-based storage.
4. Find a comfortable place to locate your computer workstation. Make sure it's located where there's subdued light, plenty of ventilation, and access to an electrical outlet. Then, adjust your chair, keyboard, mouse, and display for ergonomic comfort.

Phase 2: Drawing the Perspective

(Hand-Drafting Instructions)

1. Tape down a blank exercise worksheet to your drafting surface and begin creating a perspective for the exercise you've selected. As you draw, vary your line weights to highlight the differences between Objects or surfaces in perspective and construction lines. Draw Object or surface perimeter lines much darker than construction lines.
2. As your drawing progresses, make whatever adjustments, corrections, or improvements you deem necessary.
3. Dust off your worksheet from time to time. Dust, grime, and erasure shavings have a tendency to accumulate on your worksheet as you draw.
4. If you need more than one work session to complete the exercise, gather up, dust off, and store your work-in-progress and all your supplies and equipment at the end of each work session
5. Pick up where you left off until the exercise is complete.

(CAD Instructions)

1. Select the workbook exercise you're interested in drawing and start a new CAD drawing.
2. Copy everything you see from the downloaded worksheet into your CAD drawing exactly as you see it.
3. Begin drawing your perspective. Make use of your system's built-in layering and color-coding capabilities as you draw. This will help minimize any confusion that may arise as you add construction lines to your drawing. Layering can be used to control line visibility, and colors can be used to control plotted line thickness.
4. As your drawing progresses, make whatever adjustments, corrections, or improvements you deem necessary.
5. Save your work frequently
6. You may need more than one work session to complete each exercise. If that's the case, make a backup copy of your work. Copy all the digital files associated with each exercise to an alternate location (e.g., a USB memory stick, an external hard drive, or a Cloud-based storage system).

7. At the start of your next work session, pick up where you left off until the exercise you've been working on is complete.

8. After completing each exercise, make a backup and store it in a safe and accessible location.

Phase 3: Feedback and Closeout

1. Carefully examine the solutions you've downloaded from the Oro Editions website earlier. You'll note that each solution contains of at least two illustrations. One shows how the correct solution was constructed. You'll note that on some of the solutions, projection lines between the Station Point, Object corners, and Vanishing Points have been truncated or snipped so readers could more clearly see the rest of the exercise.

2. The other illustrations show the correct, "cleaned-up" solution without construction lines. Review the solution sheets carefully and compare them to your own drawings. Based on the comparison, you may want to retry an exercise.

3. Store all your completed work in a safe and accessible spot so it can be easily retrieved in the future.